Mark Kistler's Drawing in 3-D Wacky Workbook

The Companion Sketchbook to Drawing in 3-D with Mark Kistler

Created by Mark and Stephen Kistler

A Fireside Book
Published by Simon & Schuster

FIRESIDE
Rockefeller Center
1230 Avenue of the Americas
New York, NY 10020

FIRESIDE and colophon are registered trademarks
of Simon & Schuster Inc.

Designed by Douglas and Gayle Ltd.

Manufactured in the United States of America

10 9 8 7 6 5 4 3 2 1

ISBN 0-684-85337-X

Contents

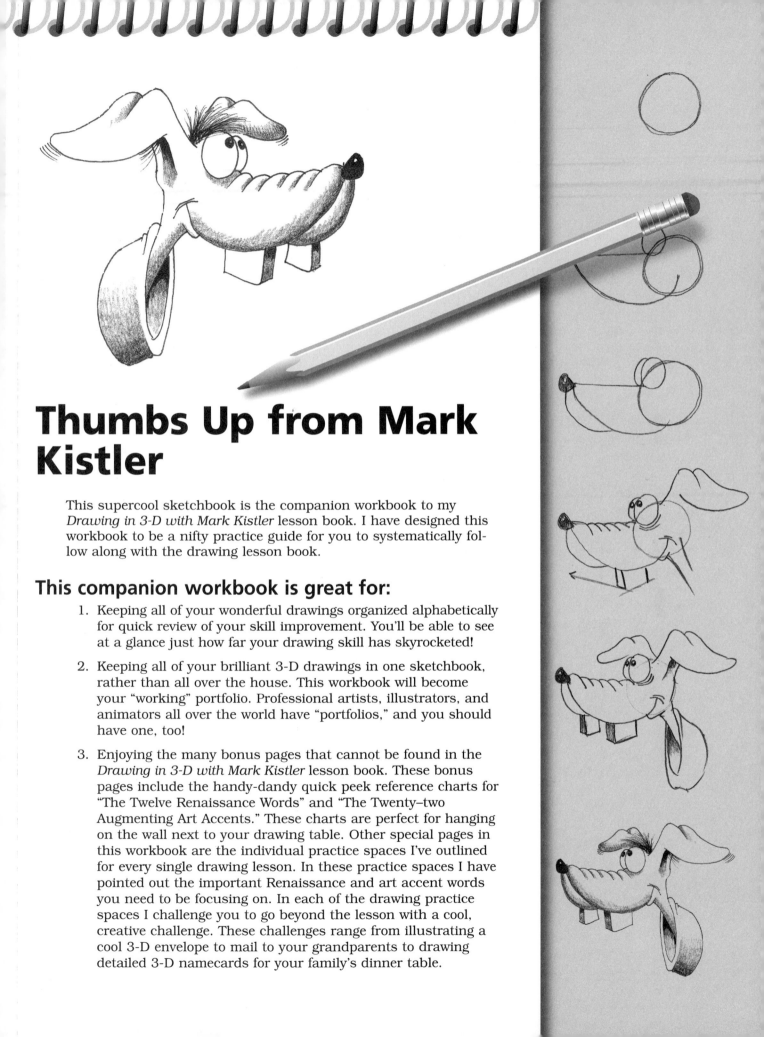

Thumbs Up from Mark Kistler

This supercool sketchbook is the companion workbook to my *Drawing in 3-D with Mark Kistler* lesson book. I have designed this workbook to be a nifty practice guide for you to systematically follow along with the drawing lesson book.

This companion workbook is great for:

1. Keeping all of your wonderful drawings organized alphabetically for quick review of your skill improvement. You'll be able to see at a glance just how far your drawing skill has skyrocketed!

2. Keeping all of your brilliant 3-D drawings in one sketchbook, rather than all over the house. This workbook will become your "working" portfolio. Professional artists, illustrators, and animators all over the world have "portfolios," and you should have one, too!

3. Enjoying the many bonus pages that cannot be found in the *Drawing in 3-D with Mark Kistler* lesson book. These bonus pages include the handy-dandy quick peek reference charts for "The Twelve Renaissance Words" and "The Twenty–two Augmenting Art Accents." These charts are perfect for hanging on the wall next to your drawing table. Other special pages in this workbook are the individual practice spaces I've outlined for every single drawing lesson. In these practice spaces I have pointed out the important Renaissance and art accent words you need to be focusing on. In each of the drawing practice spaces I challenge you to go beyond the lesson with a cool, creative challenge. These challenges range from illustrating a cool 3-D envelope to mail to your grandparents to drawing detailed 3-D namecards for your family's dinner table.

4. Inspiring you to write wonderful stories about your 3-D drawings. My big brother Stephen Kistler has helped me pack each drawing lesson with amazing alliterations, pondering poetry, and super story starters.

5. Finding detailed instructions and drawing tips for the more advanced lessons such as two-point perspective, alignment, theme pictures, and creative application of the augmenting art accents.

To help you along on your journey of creative discovery into the world of 3-D drawing, my friend and Webmaster Dennis Dawson has created an amazing Web site for you to visit. This Web site will help you build on the skills you'll be learning in this *Drawing in 3-D* companion workbook. The Internet address is www.drawwithmark.com, or you can search for key words "Mark Kistler's Imagination Station" on any search engine.

I truly hope this workbook motivates you to practice your drawing lessons every single day. I'd love to see a few of your amazing renderings, so send your drawings along with a self-addressed stamped envelope to:

Mark Kistler's Imagination Station
P.O. Box 41031
Santa Barbara, CA 93140

You are an awesome 3-D drawing, creative-thinking genius! I can't wait to see your drawings!

Dream it! Draw it! Do it!

Mark Kistler

Drawing in 3-D with Mark Kistler @ www.drawwithmark.com

Wonderful Wild Warm-ups

In the boxes below sketch the object listed quickly. We will be referring to these drawings later on in the workbook to compare your drawing skill progress. Think of this page as a measuring stick, documenting where your drawing skill level is now as compared to how far it will jump after each lesson. Spend about three minutes on each warm-up box.

Draw a rowboat:

Draw a bumble bee:

Draw a house floating on a cloud:

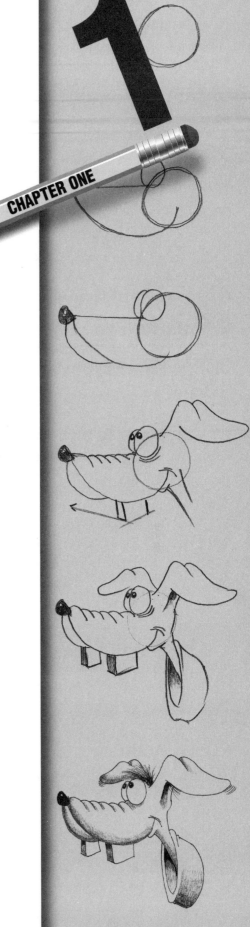

The Twelve Renaissance Words

1. Foreshortening

Squishing a shape to make one part look closer to your eye.

2. Placement

Placing an object lower on the surface of the paper will make it appear closer.

3. Size

Draw objects larger to make them appear closer. Draw objects smaller to make them appear farther away.

4. Overlapping

Draw an object behind another object to make it look deeper in your picture.

5. Shading

Add darkness to the side of an object that faces away from your imaginary light source.

6. Shadow

Add darkness to the ground next to the shaded side of an object, opposite the imaginary light source.

7. Contour

Draw lines curving around the object to give it shape and volume.

8. Horizon

Draw a line behind the objects in your picture to create a reference background edge.

9. Density

Draw objects very light and less distinct to make them appear farther away in the picture.

10. Bonus

Add billions of cool nifty extra ideas to each of your drawings! Bonus ideas are brilliant!

11. Practice

Apply these twelve Renaissance words to your drawings each and every day! Draw at least one drawing adventure in this book each day!

12. Attitude

Your brilliant superpositive mental attitude is very important when you are learning a new skill in life, especially drawing in 3-D!

Dream It! Draw It! Do It!

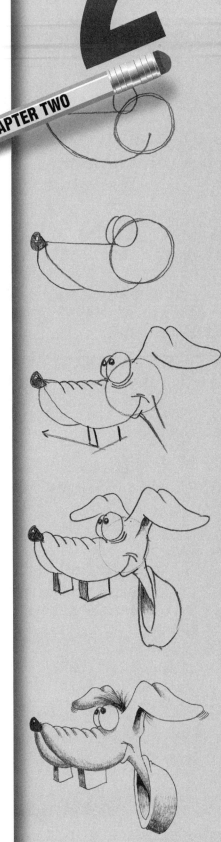

Twenty–two
Augmenting Art Accents

Duplicate this chart and carry a copy in your back pocket, hang a copy near your drawing desk, and keep a copy in your sketchbook. Use it as a reminder to combine art accents to create awesome "aesthetically pleasing" drawings. Augmenting art accents enhance your 3-D drawings to make them even more beautiful to look at. These twenty–two art words should be used with the twelve Renaissance words to create powerful eye catching 3-D masterpieces.

1. Balance

Equalize your drawing.

2. Color

Enhance, identify, and enlighten your drawing. A little bit goes a long way.

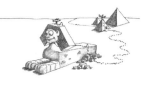

3. Grouping

Avoid "clutter"; draw objects in "families."

4. Natural Design

Nature is the best design teacher.

Nature is the best design teacher.

5. Plaid and Checkers

Draw patterns on blank surfaces for visual effect.

6. Proportion

Identify the size relationship of objects.

7. Repetition

Repeating patterns are pleasing to the eye.

8. S Curve

Flowing lines add style to your picture.

9. Silhouette

Separate and identify distance of objects with bold, dark shapes.

10. Skewed Curve

Curve some lines more at one end than the other.

11. Spiral

Patterns create rhythm in your picture.

12. Splash

Add action and movement lines away from one source.

13. Spots

Surface patterns identify objects while adding more character.

14. Stripes

Vertical, horizontal, or diagonal lines repeating a pattern.

15. Sunburst

Lines, colors, or patterns radiating from a central point.

16. Symmetry

Similar shapes drawn on opposing sides of a picture for balance and effect.

17. Taper

Lines or objects that are wide at one side and narrow at the other.

18. Texture

Patterns creating a visual feeling for the surface of an object.

19. Tilt

Leaning an object to add character and effect.

20. Twist

Bending or knotting an object to add interesting character.

21. Value

Adding different tones of color or shading for contrast.

22. Variety

Creative changes in repeated objects or patterns for a visually pleasing aesthetic effect.

Augmenting art accents equal delicious visual treats for your eyes!

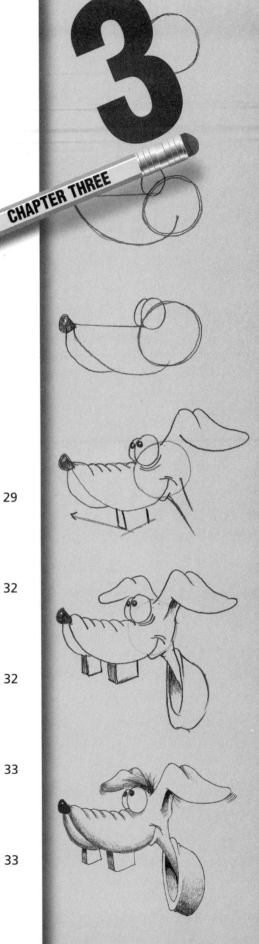

CHAPTER THREE

3

Dynamic Drawing Directory

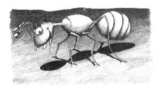

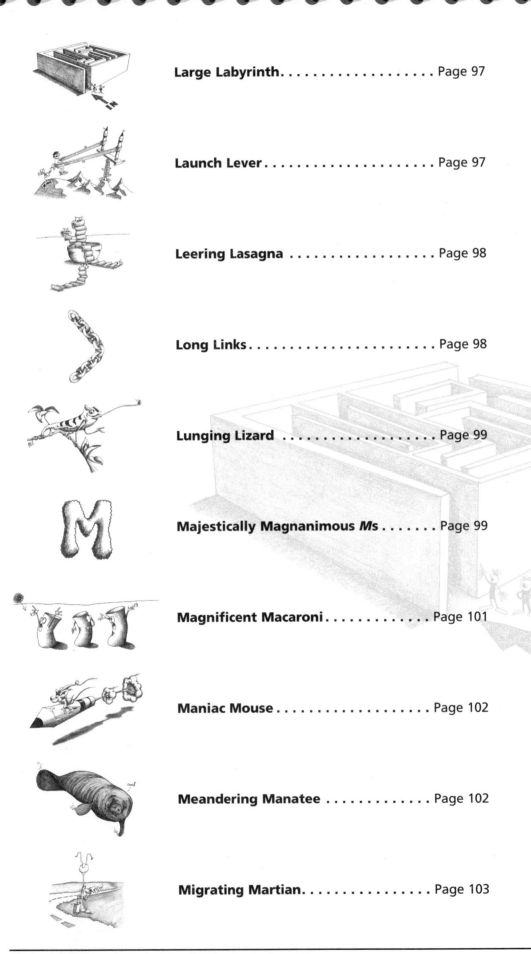

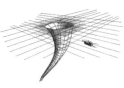

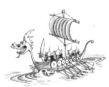

Lessons *A* to *Z*
Practice Pages

Puff Cloud Letter *A*

Practice drawing three Puff Cloud Letter *A*s in the space below. Use Blocking to build your drawing and use the Renaissance words "overlapping" and "shading." Use the augmenting art accents natural design and repetition. Follow the lesson directions on page 46 in your *Drawing in 3-D* book.

Awesome art activity: Draw your grandparents' name in puffy 3-D lettering on an envelope. Write them a fluffy, lovely letter and mail it to them. Now you are distributing your amazing artwork through the United States Postal Service, not to mention how happy your grandparents are going to be when they receive your letter.

Peeling Shadow Letter *A*

Sketch four Peeling Shadow Letter *A*s in the space below. Start by blocking in the shape. Follow the lesson directions on page 47 in your *Drawing in 3-D* book. Pay attention to your use of the Renaissance word "shadow." Augmenting art accent alert! Taper, symmetry, balance, and tilt.

Chiseled-Stone Letter *A*

Create four Chiseled-Stone 3-D Letter *A*s in the space below. Follow the lesson directions on page 47 in your *Drawing in 3-D* book. Put some pressure on your pencil to make the background value really dark. What other augmenting art accents are we using in this lesson? Try texture, color, taper, natural design, and others.

Super 3-D Letter *A*

Before you begin the lesson, practice drawing eight foreshortened squares in the space below. Now that you are getting more confident with your pencil, draw three Super 3-D Letter *A*s. Follow the lesson instructions on page 48 in your drawing book.

1. Using the chart on pages 5–6, list five Renaissance words you have used in this drawing.

2. Using the chart on pages 7–9, list four augmenting art accents you have used in this drawing.

Cool creative challenge: Illustrate your friends' names on their lunchbags with finely detailed super 3-D lettering. Your artwork is now displayed around your entire school.

Answers:

2. Variety, balance, symmetry, value, and perhaps a bit of texture.

1. Foreshortening, size, shadow, shading, horizon, overlapping, and even bonus.

Block 3-D Letter *A*

Before drawing the lesson, practice sketching five more foreshortened squares below. Now illustrate three Block 3-D Letter *A*s below using blocking light lines to mold your beginning shape. Concentrate on how blocking in the drawing gives you a feeling of confidence when you start to add the dark defining details to the drawing.

Amazing Ants

Draw two Amazing Ants in the space below. Follow the lesson instructions on page 50 in your drawing book. Focus first on blocking the shape in, then add the dark outlines. Contour lines add volume and shape to the ant's thorax; shadow will lift the ant off the ground on its legs; and size will make the near legs, antenna, and eye look closer to your eye. See if you can find two more Renaissance words used in this picture. Use your paper stump to blend the shading on the ant's body and to blend the value of the background below the horizon line.

Ant Man

In the space below render five Ant Man drawings. Begin with blocking, add details, and refine with the Renaissance words. Elaborate your sketch with some awesome augmenting art accents. Follow the instructions on page 51 in your lesson book.

Apple Appetite

In the space below create eight Apple Appetite drawings. In these practice sketches I want you to really work on your blended shading. Use your finger or a paper stump to neatly blend the shading from dark to light away from your imaginary light source. Follow the instructions on page 53 in your drawing lesson book.

Ascending Achievement

Before you begin this lesson, practice drawing ten more foreshortened squares in the space below. Think of this as stretching your imagination brain muscles before the main drawing event. Olympic athletes stretch their muscles before they run and jump, and symphony musicians warm up their fingers and lips by playing musical scales. You warm up your pencil power engines by drawing foreshortened squares! Follow the lesson on page 54 in your drawing book and draw one large multilayered Ascending Achievement step building below.

Cool creative challenge: Look in the dictionary and write in the definitions for the following terms that describe your ability to achieve goals:

1. Relentless

2. Extraordinary

3. Amazing

Asteroid Astronauts

Warm up your fingers for this lesson by drawing fifteen foreshortened circles in the space below. Draw two dots far apart. Now, instead of placing your finger in the middle as you do with the foreshortened square, go ahead and connect the dots with a very skinny hot dog shape. This squished circle is now foreshortened. Foreshortened circles are very important in helping you draw curving objects in three dimensions. Draw two very detailed renderings of floating asteroids overlapping each other. Begin as always with blocking. Carefully rotate the foreshortened circles around the spheres following the directions on lesson page 56 in your drawing book.

Cool creative challenge: Fill in the following sentences after reading the lesson text in your drawing book.

If the crater is on the right side of the sphere, the thickness is on the _____.

If the crater is on the left side of the sphere, the thickness is on the _____.

If the crater is on the top side of the sphere, the thickness is on the _____.

If the crater is on the bottom side of the sphere, the thickness is on the _____.

Atomic Android

Draw fifteen foreshortened squares in the practice space below. Count how many foreshortened squares you have practiced so far in this workbook. Quite a few, eh? You are now quickly evolving into a foreshortening expert. Concentrate on using the Renaissance word "size" by drawing the near arms and legs larger to make them look closer to your eye. Size will pull larger things toward you and push smaller objects away from you. Pay attention to the augmenting art accents I have used in this lesson (repetition, balance, stripes) and try adding a few of your own creative artistic touches. The twenty–two augmenting accents are there on pages 7–9 for you to use! Use them often; they will unleash your wild imagination across the paper!

Puff Cloud *B*

Create a soft, fluffy texture to four letter *B*s in the space below. Rotate your light source to experiment with shading. Concentrate on the augmenting art accents texture, repetition, and variety.

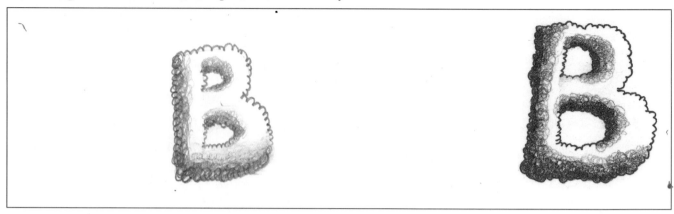

Cool creative challenge: Look through some Dr. Seuss books and find some clouds that Theodor Geisel has drawn. Study how he created the puffy texture. How did he shade his clouds? How does he make one cloud look closer than another cloud? Draw five Dr. Seuss–style clouds in the space below.

Peeling Shadow Letter *B*

Draw three Peeling Shadow Letter *B*s in the space below. Focus your attention on how the shadow peels away from the letter. Try making the shadow peel away from the letter *B* from the right side. How would you peel it up from the bottom edge?

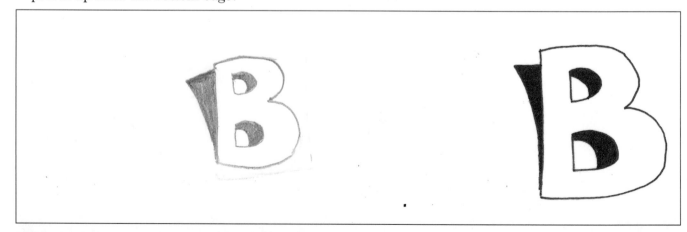

Cool creative challenge: Draw labels for items in your refrigerator in peeling shadow style. Imagine what your parents will say when they open up the fridge for an apple and see your nifty 3-D labels taped to everything, even the apples!

Chiseled-Stone Letter *B*

Chisel out five letter *B*s in the practice space below. I want you to really darken in the background texture behind the letter. This dark value will create a dynamic contrast against your letter, making it pop right off your paper.

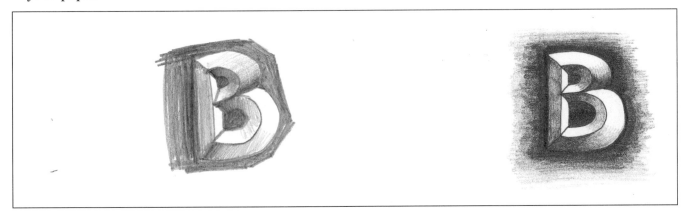

Diligent daring dictionary drill:

Look up and define the word "contrast": _____

Super 3-D Letter *B*

Render three beautiful Super 3-D Letter *B*s in the practice space below. Use shadow to create the visual effect of hovering. Draw the beginning foreshortened square carefully. Have fun with this syle; these letters look cool.

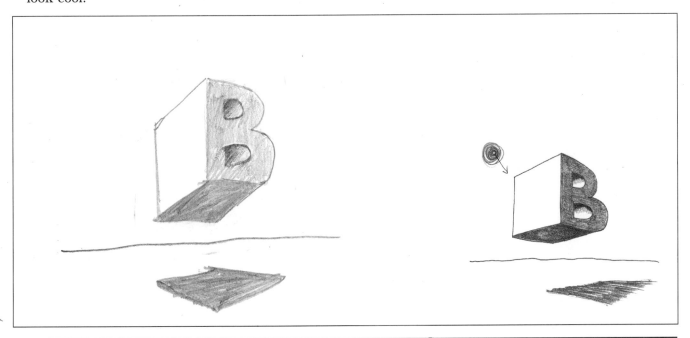

Awesome alliteration attack! Try to write a *B* alliteration longer than my big brother Steve's! Be brave bringing big bears beyond Bolivia's border!

Try yours: _____

Block 3-D Letter *B*

Here's a little different practice assignment. In the space below, draw twelve Block 3-D Letter *B*s in a row, disappearing into the background. Also look at the lesson Question Queue on page 121 in this book to get a better idea of what your Block 3-D Letter *B*s will look like.

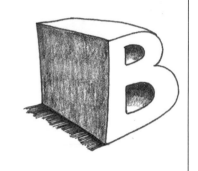

Cool creative challenge: Have your parents find you a nonpermanent overhead-projector pen at a local office supply store for around $.70. With your parents' permission, secretly draw a great "good morning" note in Block 3-D letters for your brothers and sisters on the bathroom mirror. After everyone enjoys your artwork, use paper towels to wipe off the mirror. Clean the mirror off before everyone takes their morning showers, or the color may drip with the shower steam.

Banana Boy

Have fun practicing seven Banana Boys and girls in the space below. Follow the lesson on page 62 in your lesson book. Use the augmenting art accents tilt, taper, and S curve to give your banana people a lot of expressive character.

Bat Bean

Another fun cartoon character to practice the Renaissance words! Follow the lesson on pages 62–63 in your lesson book to sketch four Bat Beans below. These could be lima, pinto, or even green beans! How about trying a human bean! Use contour lines on the belt, and partial sunbursts form the elbows to draw the bat wings. The mask creates a nice facial silhouette. The shadow is squeezed between each of the toes on the ground.

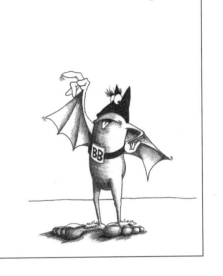

Another amazing alliteration Augmentation:

Stephen's turn: Bat Bean blows big bubbles below Bermuda!

Your turn:_____

Big Bugeye Birds

Stretch your imagination in the empty space below by practicing eleven Big Bugeye Birds in 3-D. Use the augmenting art accent natural design to create the feel of natural feathers on the birds. Use variety to make some feathers larger than others. Use repetition in the patterns the feathers create as they fill in the texture of the bird's body. The tall bird's feet use partial sunbursts to spread the toes out from the heel. For more variety I've drawn actual toenails on the short chubby bird. What creative changes will you draw on your Big Bugeye Birds? Follow the lesson page 63 in your lesson book.

Billions of Blocks

Now we are going to jump the skill level up several notches. This is a drawing that I usually do with older high school students. Since you are progressing so rapidly through this workbook, I'm confident you will blast this drawing out with no problems. Follow the lesson on page 64 in your lesson book. I recommend using a clear plastic ruler as a straight edge to line up all of your guidelines to the central point. Another cool trick of the trade is to tape a piece of string on the center vanishing point. Hold the loose end in your hand and rotate the string to the corners of each building. You'll notice that the string will guide your pencil lines accurately to the vanishing point. Pretty clever, eh? There is ample opportunity for you to use the Renaissance words and art accents in this drawing. The buildings rapidly shrink in size as they move toward the street far below. Shading helps identify which sides of the buildings are away from the sun. Repetition, variety, and balance are used to create an intriguing cityscape; repetition on the pattern of street lanes; variety in the different sizes and shapes of the buildings; and balance to draw equal weight around the city block, to keep your eye drawn toward the center. In my picture I need a few more small buildings in the lower left-hand block to balance this picture, How about your city drawing?

Biosphere Building

Wow! You are going to thoroughly understand the important Renaissance word "overlapping" after practicing twenty foreshortened-square Biosphere Buildings in the big blank space below. Follow the lesson on page 65 in your lesson book. Keep an eye on your foreshortened squares. Draw those two middle dots close together in the middle. You will also be practicing a lot of foreshortened circles in the flowing banner. Draw at least five flag poles with flowing banners on your overlapped city buildings below. Also, add at least three windows, holes, doors, or balconies to each building by using the augmenting art accents variety, repetition, balance, and variety. Remember the thickness rules: "If the window is on the right side, the thickness is on the right side; if the window is on the left side, the thickness is on the left side; if the window is on the top, the thickness is on the top edge."

Magnificent mural madness: Use a giant piece of paper and draw a gigantic Biosphere Building megalopolis with at least one hundred buildings overlapping each other. You can get your friends to help you draw and shade this twelve-hour project. Please do not stay up past 3:00 A.M. drawing this magnificent mural. I don't want to be responsible for you being cranky at school the next day!

Bizarre Breakfast Bowl

Curving surfaces are great for practicing blended shading with your paper stump drawing tool. In the space below, practice sketching six Bizarre Breakfast Bowls. Follow the lesson on page 66 in your lesson book. Use your paper stump to gradually blend the shading from the dark underneath area to the light top side. This blending process is reversed on the inside of the trough to create the illusion that it is hollow. Notice the neat area next to the pile of cereal that you can really get some dark tone in. Always keep your eyes open for neat little nooks and crannies that you can darken in to create a value contrast. This contrast will push objects up off your paper toward your eye. Once again, we are victorious in our effort to create a wonderful 3-D illusion of depth on your paper. Congratulations!

Boisterious Brain

Practice drawing one giant Boisterous Brain in the space below. Repeating the overlapping curves creates a cool 3-D maze effect. Here's an idea; Turn your Boisterous Brain into a really neato maze for your friends to figure out. Use a guideline to place your shadow on the ground next to the big, bulging brain. Add lots of your own bonus ideas to make this drawing your own unique creation. I've added the Bonus ideas of eyes with long eyelashes and comic text balloons. I can't wait to see some of your amazing 3-D drawings. Mail me one today, would you? Include a self-addressed stamped envelope so I can mail you a drawing lesson newsletter.

Books, Books, Books!

Let your pencil power flow in the space below by drawing three stacks of library books. Foreshortened square alert! The top foreshortened squares will determine the alignment angles for the entire stack of books. Think of the balance when you draw the stack. If your stack looks like it is beginning to lean too much in one direction, just draw an umbrella or something leaning against the stack to hold it up. Aha! Imagination is more powerful than erasers! You don't need to erase mistakes, just figure out a way to work the mistake into your rendering.

Buzzing Beehive

This is a fantastic drawing to practice the Renaissance word "size." The bees farther away are very small. Follow the lesson on page 69 in your lesson book and draw a Buzzing Beehive scene in the space below. The big bee is drawn large to capture your attention in the picture and to make it appear closer to your eye. Use contour lines to wrap around the bee's abdomen. The art accent natural design helps identify the bee's middle section (thorax) with repeated fur patterns. Natural design also gives the tree branch and beehive a nice surface texture. Use your paper stump to blend the shading on this picture. For variety, add some twigs with leaves and more knotholes to the tree. What art accent are you using in the pattern of lines on the bee's eyes? We are using the Renaissance word "density" for the very first time in these lessons. The bees that are very far away are drawn lighter and less distinct than the closer bees. Things that are farther away lose their detailed density and become hazy with distance.

Puff Cloud Letter C

Create a nice soft fluffy texture on five Puff Cloud Letter Cs in the space below. Follow the lesson on page 70 in your lesson book. Use repetition and texture to create a variety of bumpy cloud outlines.

Peeling Shadow Letter C

Sketch five Peeling Shadow Letter Cs in the space below. Draw the peeling shadow very dark to create a sharp contrast in the pencil tones' value.

Chiseled-Stone Letter C

Draw seven Chiseled-Stone Letter Cs in the space below. Make the background texture superdark to create the sharp contrast with the edges of the letter. Use your paper stump to blend the shading inside the curve and the bottom edge of the letter C.

Super 3-D Letter C

Before drawing this lesson, practice drawing six more foreshortened squares to warm up your genius, drawing in 3-D, creative brain cells. Now illlustrate four Super 3-D Letter Cs in the pencil power practice space below.

Block 3-D Letter C

Before starting this drawing lesson, warm up your nimble artistic fingers by practicing eleven foreshortened squares in the space below. Remember, "foreshortening" is one of the most important of the twelve Renaissance words. Render three brilliant Block 3-D Letter Cs below. Use a strong guideline to place your shadow on the ground. Add a horizon line behind the block letter C to place it firmly on the planet's surface. Use your paper stump to blend the shading from the dark area away from the sunlight, to the lighter top surface. Also, blend a little on the inside shelf of the letter.

Career Cartoonist

Illustate a busy cartoonist furiously working to make a publishing deadline. Add the family dog growling for food. Follow the lesson on page 72 in your lesson book. Use lots of bonus ideas to create a real crazy look of busy chaos on the desk surface. You can go nuts with art accents on the high-tech gizmo lamps and nifty pencil holders. Variety, repetition, balance, S curves, texture, and proportion come to mind. I used grouping to gather little families of items together, creating some order in the mass chaos. A group of books on one side of the desk is balanced by drawing a group of scattered pencils and a pencil holder on the opposite side of the desk. Grouping and balance often work together to create a nice aesthetically pleasing picture for your eyes to enjoy. Aha! The augmenting art accents truly are scrumptious visual desserts for your eyes to consume. Yummy!

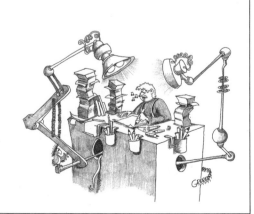

Cloud Cottage

Follow the lesson on page 73 in your lesson book. Sketch three cottages nestled in a group of clouds in the space below. Use the Renaissance word "overlapping" on the bottom edge of the cottages to make them appear to be settling into the cloud. Blended shading is another important Renaissance word you need to use, so pull out your paper stump! Prepare to blend! The wrinkles on the roof are good examples of the art accent variety. Put lots of little spiffy details, add lots of bonus ideas to make the drawing full of your personality.

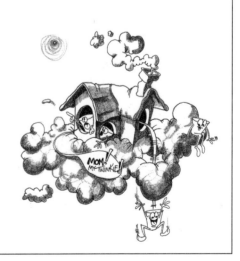

Stephen's super story starter for you to complete:

Colorful Coral

Use the entire space below to create a beautiful undersea odyssey of coral, kelp, sea urchins, starfish, eels, jellyfish, and zillions of extra bonus ideas. Spend at least forty–five minutes on this wonderful practice exercise. Follow the directions on page 74 in your *Drawing in 3-D* lesson book. Notice how many foreshortened circles we use in drawing the tube coral. We are also using the Renaissance word "placement" by drawing objects lower in the scene to make them appear closer to your eye. Overlapping is a powerful help to push many objects back behind the coral away from your eye. Now it's time for you to experiment with the augmenting art accent color. Pick a few colored crayons. For this exercise use one color to identify all the tube coral, another color to identify all the starfish, and yet another to give the water a comfortable hue. Of course in future drawings you can use twenty different colors to tone in your tube coral. I just wanted to illustrate how color can help identify an object, separating it from other details in a picture. Take a look at the cover of your *Drawing in 3-D* lesson book. Notice how I've used color not only to identify and separate objects, but also to shade and add texture. Color is a fantastic tool to use. A littler bit of color can go a long way. On the other hand, a lot of color can create a dynamic eye-catching experience in your picture. It's your choice, your picture, your imagination—have fun and experiment with color!

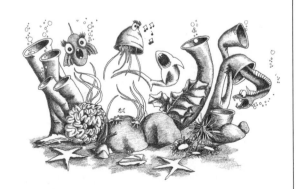

Colossal Castle

We have reached an exciting milestone together! Finally, after successfully completing thirty-seven drawing lessons together, we are now ready to learn how to use the "vanishing two-point perspective" system. I don't agree with the name of this system of "perspective." It really should be called alignment but we will go with perspective because that is what artists have been calling it for the last century. Follow the lesson on page 76 in your lesson book. Use the clear plastic ruler you used when you sketched the Billions of Blocks in this workbook. Use the clear plastic ruler because you will be able to see through this straight edge to line up with objects drawn underneath it. Use the ruler to draw most of the guidelines in advance. Begin with the vertical lines, place all the vanishing guidelines, and add the edges and details. These vanishing point guide dots will help you create size efficiently in your picture. This system is nearly foolproof and can be used with even huge drawings with lots of different objects to fit in.

Cool Canyons

Practice drawing one super-detailed Cool Canyon in the blank space below. Follow the lesson on page 77 of your lesson book.

Crane Contraptions

Use your awesome imagination power and sketch four really funky Crane Contraptions below. Follow the lesson on page 78 of your lesson book.

Crater Cave

Launch your pencil power across the page below and practice drawing one extremely intricate Crater Cave. Concentrate on how you use that powerful Renaissanse word "overlapping" to make some of the craters really pop off the page toward your eye. Follow the lesson on page 79 of your lesson book.

Crawling Cobra

Create a scene of Crawling Cobras slithering across the page below. Maybe they all could be heading over to your house for a great game of Monopoly! Follow the lesson on page 80 of your lesson book.

Puff Cloud Letter *D*

Use your pencil to draw seven soft puffy Puff Cloud Letter *D*s in the practice space below. Keep your hand relaxed and draw the curving lines to create the puffy edge. The radical Renaissance words we are using in this practice space are "shading" and "overlapping." You will also be applying awesome augmenting art accents of texture, repetition, value, natural design, and variety. Puffy cloud letters are fun! Go on, draw seven puffy letters below.

Peeling Shadow Letter *D*

Let's harness that wonderful enthusiasm of yours! I want you to draw five unbelievably cool Peeling Shadow Letter *D*s. Focus on how the shadow peels away from the letter. You can experiment with the shadow and peel it away from the bottom, top, or other side of the letter. Come to think of it, the shadow can also be a silhouette of the letter! Once again, the Renaissance words and the augmenting art accents work together to create a wonderful three-dimensional letter that looks aesthetically beautiful! 3-D lettering is so cool!

Chiseled-Stone Letter *D*s

Pretend that the pencil power practice space below is a slab of blank stone. Out of this blank slab chisel eight very sharp-looking Chiseled-Stone Letter *D*s. Now you can consider your pencil a sculpting tool. Be sure to use lots of dark value behind the letter, creating a dynamic contrast between the background and the edge of your stone. Practice rotating the shading on each one, pretending the light source is coming from different angles. Use your paper stump to blend the shading nicely from dark to light.

Super 3-D Letter *D*s

Before drawing your Super 3-D Letters below, I want you to warm up your paper-dominating positive attitude by practicing five foreshortened squares in the space below. Foreshortened squares are the building blocks of almost every 3-D drawing you will be creating.

Block 3-D Letter *D*

It's time to practice sketching foreshortened squares again! Before working on the Block 3-D Letters, draw eight more foreshortened squares in the practice space below. I know it seems that I'm making you practice these a million times, but you really need to be confident when drawing these shapes. Now draw five Block 3-D letters below.

Daring Driving Dogs

Boldly illustrate an entire fleet of Daring Driving Dogs below. Follow the lesson on page 83 of your *Drawing in 3-D* lesson book.

Deep Space Droid

Be Daring! Be Diligent! Be Dynamic! Draw one hundred seventeen Deep Space Droids in the space below. Follow the lesson on page 83 of your lesson book.

Dirk's Declaration

Using one-point perspective, draw the interior of Dirk's reception hall in the practice space below. Follow the one-point perspective lessons on page 84 in your lesson book. Remember to use a clear plastic straight-edge ruler to keep all of your guidelines lined up to the center vanishing point. Look at Billions of Blocks in this workbook for a quick review on how to use one-point perspective in your picture.

Dog Dude

Sketch eleven Dog Dudes in the practice space below. Follow the lesson on page 86 of your lesson book.

Drooling Dragon

Transport yourself back into the medieval times of kings, castles, and dragons with pencil power. In the practice space below, illustrate a family of twenty Drooling Dragons in a cool 3-D cave. Use the augmenting art accents twisting, variety, and taper to twist all of their tails into intricate 3-D knots.

Puff Cloud Letter *E*

Use your pencil to draw seven soft Puff Cloud Letters in the practice space below. Keep your hand relaxed and draw the curving lines to create the puffy edge. Follow the lesson on page 87 of your lesson book.

Peeling Shadow Letter *E*

Draw five unbelievably cool Peeling Shadow Letters. Focus on how the shadow peels away from the letter. You can experiment with the shadow and peel it away from the bottom, top, or other side of the letter. Come to think of it, the shadow can also be a silhouette of the letter! Once again, the Renaissance words and the augmenting art accents work together to create a wonderfully cool three-dimensional letter!

Chiseled-Stone Letter *E*s

Pretend that the pencil power practice space below is a slab of blank stone. Out of this blank slab chisel eight very sharp-looking Chiseled-Stone Letters. Be sure to use lots of dark value behind the letter, creating a dynamic contrast between the background and the edge of your stone. Practice rotating the shading on each one, pretending the light source is coming from different angles. Use your paper stump to blend the shading nicely from dark to light.

Super 3-D Letter *E*

Before drawing your Super 3-D Letters below, I want you to warm up your paper-dominating positive attitude by practicing five foreshortened squares in the space below. Illustrate six Super 3-D Letters below. Concentrate on using size, foreshortening, shading, horizon, shadow, practice, attitude, and bonus. Can you determine which augmenting art accents we will use to make this letter look even more visually cool?

Block 3-D Letter *E*

It's time to practice sketching foreshortened squares again! Before working on the Block 3-D Letters, draw eight more foreshortened squares in the practice space below. Now draw five Block 3-D Letters below.

Early Egyptian

I love traveling through time with pencil power! In the practice space below, let's travel back to the land of ancient Egypt! Draw forty pyramids in the "Valley of Kings" below. Add the Sphinx in 3-D and the meandering foreshortened Nile River running through the entire picture. Follow the lesson on page 88 in your lesson book.

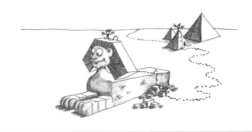

Augmenting art accents to watch for: Balance is achieved in this drawing by adding the pyramids and the dotted trail to the right side of the picture to counter the dominant visual weight of the Sphinx. Sunburst is a nice repeating pattern radiating out from a central point. Look at the headpiece on the Sphinx; all the lines radiate from a center point on its nose. By grouping the pyramids, the piles of rubble, and the texture on the Sphinx's foot, we create a visually pleasing drawing. Texture is created by drawing a few groups of tiny bricks to represent the entire surface texture of the Sphinx.

You see? Even in this simple cartoon we can use many of the augmenting art accents to enhance our 3-D drawings.

Eccentric Elephants

Not only can you travel through time and space with pencil power, but you can travel to different continents on planet Earth. Let's fly our pencil rockets over to the plains of Africa. Draw twelve African elephants in the practice space below. Follow the lesson on page 89 of your lesson book.

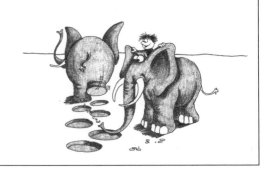

Key Renaissance words to watch for: "foreshortening," in the shape of the footprints; "contour," in the curving lines that give the trunk its shape "size," in the near tusk horn that is drawn larger and in the sister elephant walking away that is drawn smaller; "horizon," in the background line that gives us a sky reference point; "shading," in the dark tone that is blended on the left side and inside the ear.

Which way is the light shining in this picture? I used a paper stump blending tool in this drawing. Have you gotten a paper stump yet? It makes great 3-D shading tools.

Eeek Squeaks

Squeak out seven Eeeks in the practice space below. Use a nice, flowing guideline to create a fluid look of action in your sketch. Follow the lesson on page 90 of your lesson book.

Elevated Earth Equalizer

Elevate your positive attitude by drawing six Elevated Earth Equalizers in the practice space below. Use lots of bonus and variety in the picture by connecting all six together with a series of intricate, detailed, intertwining tubes. Follow the lesson on page 90 of your lesson book.

Elf's Ear

Create a magical mythological illustration of fairies and elves in the practice space below. Follow the lesson on page 91 of your lesson book.

Emotional Eyeball

Drawing in 3-D is such an overwhelmingly emotional experience. In the practice space below, draw thirty Emotional Eyeballs weeping with joy as they look at your brilliant 3-D drawings. Follow the lesson on page 91 of your *Drawing in 3-D* lesson book.

Enchanted Eagle

Let your paper-dominating attitude soar with the eagles! In the practice space below, render an entire flock of Enchanted Eagles riding the thermal winds of your powerful imagination! Follow the lesson on pages 91–92 of your lesson book.

Enthusiastic Environmentalist

Now you are even saving the planet with your amazing 3-D drawing skill. You are truly a wonderful citizen of Earth! You've created the ultimate recycling machine in the practice space below. Reduce! Reuse! And recycle! Make sure to draw the machine with ten extra connecting blocks all lined up. This is a great foreshortening exercise. We are also using size by drawing the farther blocks smaller as they move away from our eye. Follow the lesson on page 92 of your lesson book.

Puff Cloud Letter *F*

Use your pencil to draw seven soft Puff Cloud Letters in the practice space below. Follow the lesson on page 93 of your lesson book.

Peeling Shadow Letter *F*

I want you to draw five unbelievably cool Peeling Shadow Letters. Focus on how the shadow peels away from the letter.

Chiseled-Stone Letter *F*

Chisel out eight very sharp-looking Chiseled-Stone Letters.

Super 3-D Letter *F*

Before drawing your Super 3-D Letters, I want you to warm up by practicing five foreshortened squares in the space below. Then illustrate six Super 3-D Letters.

Block 3-D Letter *F*

It's time to practice sketching foreshortened squares again! Before working on the Block 3-D Letters, draw eight more foreshortened squares in the practice space below. Now draw five Block 3-D Letters below.

Fearless Floating Frogs

Let your pencil smoothly drift down the river of your imagination. In the space below draw eight lily pads with a 3-D family of five fabulously friendly Fearless Floating Frogs on each. Add lots of foreshortened water-current lines in the picture. Follow the lesson on page 95 of your lesson book. Find where I've used these augmenting art accents to make my drawing more interesting and fun to look at: spots, value, grouping, variety, splash, sunburst, tilt, balance, texture, and taper. Notice how I "drooped" one of the leaves. I love to droop a few objects in most of my drawings. This word is so cool and so effective in enhancing a drawing that we should include this as an official augmenting art accent.

Finicky Fanged Fish

Go nuts with bonus and variety in the practice space below. Draw a school of nineteen really funky, cool, creative Finicky Fanged Fish! Follow the lesson on page 96 of your lesson book. Make each one unique and special. Let your brilliance reflect through your creative sketches!

Forest of Freedom

Your 3-D drawing skill is really "branching" out across this sketchbook! Your imagination is "rooted" in the Renaissance words! Your brilliant brain is literally a forest of ideas! In the practice space below sketch a thick forest of trees using one-point perspective. Follow the lesson on page 97 of your lesson book. Other one-point perspective drawings to practice in this workbook are Question Que, Billions of Blocks, Good Grade, and Dirk's Declaration.

Fred's Foot

Flop along with Fred! In the practice space below, draw Fred and his friends all with one enormous 3-D foot. This is a wonderful practice drawing for overlapping and size. Use bonus when you add the little nifty details like the toenails. Follow the lesson on pages 99 and 100 of your lesson book.

Funky Flying Faucets

This jumbo jet is modified to water the drought-stricken regions of planet Earth. Your awesome imagination power has conjured up these 3-D designs to build this flying water spigot. The nations of the planet now consider you the hero of creative problem solving. You never cease to amaze me! In the practice space below draw a squadron of seven Funky Flying Faucets. Follow the lesson on pages 100 and 101 of your lesson book.

Furry Franco from France

Hurry! Draw Furry Franco escaping the giant hairy foot of my brother Karl!
Karl's shadow is fast approaching, yikes! Follow the lesson on pages 101
and 102 of your lesson book.

Puff Cloud Letter *G*

Use your pencil to draw seven soft Puff Cloud Letters in the practice space
below. Follow the lesson on page 103 of your lesson book.

Peeling Shadow Letter *G*

I want you to draw five unbelievably cool Peeling Shadow Letters. Focus on how the shadow peels away from the letter.

Chiseled-Stone Letter *G*

Chisel out eight very sharp-looking Chiseled-Stone Letters.

Super 3-D Letter *G*

Before drawing your Super 3-D Letters, I want you to warm up by practicing five foreshortened squares in the space below. Then illustrate six Super 3-D Letters below.

Block 3-D Letter *G*

Before working on the Block 3-D Letters, draw eight more foreshortened squares in the practice space below. Now draw five Block 3-D Letters below.

Giant Giraffe

Gracefully gallop a herd of Giant Giraffes in the practice space below. Follow the lesson on page 104 of your lesson book. Watch for the Renaissance words being used to create a "popping off the paper" 3-D illusion: using "placement," the near foot is drawn lower on the paper; using "horizon," the background reference line for your eye is drawn behind the object; and using "bonus," details are added to the fancy tail with action lines, the curly hair, detailed spots, and long eyelashes.

Ginger George

Draw a crowd of forty-three gingerbread people in the practice space below. Follow the lesson on page 105 of your lesson book. Use blocking to lightly sketch in a long row of ginger dudes. Use the Renaissance words "size," "overlaping," "placement," and "foreshortening" to make the larger ginger fellow look closer.

Gliding Gull

Let your pencil glide across the practice space below. Draw a flock of twenty-two Gliding Gulls using natural design and texture to make the wings' feathers overlap. Follow the lesson on pages 105–106 of your lesson book.

Gnome's Home

Create a land of gnomes and trolls in the practice space below. Follow the lesson on page 107 of your lesson book.

Good Grade

Since you always get such impressive grades at school let's draw a 3-D scroll to display your A+! In the practice space below, show the world your champion grades on sixteen foreshortened wall scrolls. Follow the lesson on page 108 of your lesson book.

Gorilla Games

Go "gorillas" over 3-D drawing! In the practice space below, illustrate five gorillas playing a game of chess. Follow the lesson on pages 108 and 109 of your lesson book.

Gracious God

Illustrate a picture of God's hands holding our precious planet Earth. Follow the lesson on pages 109 and 110 of your *Drawing in 3-D* lesson book.

Grandiose Grin

Drawing in 3-D always makes you grin gregariously! Draw nine faces with Grandiose Grins in the practice space below. Follow the lesson on page 110 of your *Drawing in 3-D* lesson book.

Grumpy Ghost

If you miss a day of 3-D drawing you might tend to get a bit grumpy like the seven Grumpy Ghosts below! Follow the lesson on pages 110 and 111 of your lesson book.

Puff Cloud Letter *H*

Use your pencil to draw seven soft Puff Cloud Letters in the practice space below. Follow the lesson on page 111 of your lesson book.

Peeling Shadow Letter *H*

I want you to draw five unbelievably cool Peeling Shadow Letters. Focus on how the shadow peels away from the letter.

Chiseled-Stone Letter *H*

Chisel out eight very sharp-looking Chiseled-Stone Letters.

Super 3-D Letter *H*

Before drawing your Super 3-D Letters, I want you to warm up by practicing five foreshortened squares in the space below. Then illustrate six Super 3-D Letters.

Block 3-D Letter *H*

Before working on the Block 3-D Letters, draw eight more foreshortened squares in the practice space below. Now draw five Block 3-D Letters below.

Ha! Ha! Ha!

You have so much imagination power that you can't stop laughing out loud! In the practice space below, sketch fourteen laughing faces in 3-D. Follow the lesson on page 113 of your lesson book.

Heavy Helmet

Think of this helmet as your genius 3-D thinking cap. In the practice space below, draw a huge Heavy Helmet, adding four layers of really cool extra bonus ideas. Follow the lesson on pages 113 and 114 of your lesson book.

Hiccup Headquarters

Using the two-point perspective lesson on pages 114 and 115 in your lesson book, let's draw a large building in 3-D. You can use this as your HQ for 3-D drawing, thinking, and hiccuping!

Hiding Henry

Now you will be able to see all of your foreshortened-square practice sessions paying off. Draw the 3-D box popping open below and add my brother Karl's feet sticking out. Now draw nine more smaller boxes higher up on the page toward the horizon. This uses size and placement to make Karl's box look closer to your eye. Follow the lesson on page 116 of your lesson book.

House for a Mouse

Following the lesson on page 116 in your lesson book, draw two blocks of Swiss cheese below. Connect the two with a drawbridge that the mice can scamper across. Add lots of foreshortened holes. Remember the thickness rule.

Huge Hand

I've always had difficulty drawing the human hand. This is a great space to practice drawing fourteen hands so you won't ever have any trouble adding hands to your pictures! Follow the lesson on page 117 of your lesson book.

Huge Hug

Use lots of "overlapping" wrinkles to draw three Huge Hugs in the space below. Follow the lesson on page 118 of your lesson book.

Puff Cloud Letter *I*

Use your pencil to draw seven soft Puff Cloud Letters in the practice space below. Follow the lesson on page 119 of your lesson book.

Peeling Shadow Letter *I*

I want you to draw five unbelievably cool Peeling Shadow Letters. Focus on how the shadow peels away from the letter.

Chiseled-Stone Letter *I*

Chisel out eight very sharp-looking Chiseled-Stone Letters.

Super 3-D Letter *I*

Before drawing your Super 3-D Letters, I want you to warm up by practicing five foreshortened squares in the space below. Then illustrate six Super 3-D Letters.

Block 3-D Letter *I*

Before working on the Block 3-D Letters, draw eight more foreshortened squares in the practice space below. Now draw five Block 3-D Letters below.

Idea Encyclopedia

Let's draw a library of Idea Encyclopedias to store all of your amazing creative ideas for 3-D drawings! Follow the lesson on page 120 of your lesson book.

Illuminating Idea

Your imagination illuminates the world around you! Draw twelve illuminating lightbulbs below. Follow the lesson on page 121 of your lesson book.

Intellectual Insect

This is an appropriate practice illustration for an intellectual reader such as you! Sketch a few Intellectual Insects in the practice space below. Follow the lesson on page 122 of your lesson book.

I.Q. Icon

I've always considered Albert Einstein an icon symbol for genius thinking. That is, until I looked at your genius sketches in this *Drawing in 3-D* workbook. In the practice space below, draw a self-portrait. You are the genius thinking icon now! Follow the lesson on page 123 of your lesson book.

Island Inhabitant

This is a great drawing to inspire your story-writing brain cells. In the practic space below, draw the Island Inhabitant and write a short story about it. Follow the lesson on page 123 of your lesson book.

Stephen's super story starter challenge: Finding themselves stranded on a deserted island, Ian and Laurel began immediately planning their escape. Part of their plan involved the local friendly daring dolphin pod playing nearby...(how would you escape?).

Puff Cloud Letter *J*

Use your pencil to draw seven soft Puff Cloud Letters in the practice space below. Follow the lesson on page 124 of your lesson book.

Peeling Shadow Letter *J*

I want you to draw five unbelievably cool Peeling Shadow Letters. Focus on how the shadow peels away from the letter.

Chiseled-Stone Letter *J*

Chisel out eight very sharp-looking Chiseled-Stone Letters.

Super 3-D Letter *J*

Before drawing your Super 3-D Letters, I want you to warm up by practicing five foreshortened squares in the space below. Then illustrate six Super 3-D Letters.

Block 3-D Letter *J*

Before working on the Block 3-D Letters, draw eight more foreshortened squares in the practice space below. Now draw five Block 3-D Letters below.

Jesus

Religious symbols are wonderful images to practice your 3-D drawing skill. Let your artistic passion and your joyful emotion shine through in your drawings. In the space below, draw a 3-D image of as many religious symbols of the world that you can think of. Have your parents help you. What is your religion? Planet Earth has many—Christianity, Hinduism, Judaism, Islam, and lots more. Follow the lesson on page 126 of your lesson book.

Jiggling Jellyfish

Let's go scuba diving into the ocean. Turn the practice space below into a swirling sea of Jiggling Jellyfish! Follow the lesson on page 127 of your lesson book.

Jolly Tamales

Jump! Bounce! Hop! Get your pencil plopping across the practice space below with fifty Jolly Tamales! Follow the lesson on pages 127 and 128 of your lesson book.

Jumbo Jogger

Time travel back to the land of dino-dudes. Draw eight dinosaurs racing to the waterhole in the practice space below. Follow the lesson on page 129 of your lesson book.

Jumping Jack

Jumping Jack is back to attack a sack of delicious snacks! Follow the lesson on page 130 of your lesson book and draw a cool cloud scene of sixteen Jumping Jacks.

Puff Cloud Letter *K*

Use your pencil to draw seven soft Puff Cloud Letters in the practice space below. Follow the lesson on page 131 of your lesson book.

Peeling Shadow Letter *K*

I want you to draw five unbelievably cool Peeling Shadow Letters. Focus on how the shadow peels away from the letter.

Chiseled-Stone Letter *K*

Chisel out eight very sharp-looking Chiseled-Stone Letters.

Super 3-D Letter *K*

Before drawing your Super 3-D Letters, I want you to warm up by practicing five foreshortened squares in the space below. Then illustrate six Super 3-D Letters.

Block 3-D Letter *K*

Before working on the Block 3-D Letters, draw eight more foreshortened squares in the practice space below. Now draw five Block 3-D Letters below.

Kayak Kid

Cruise the Colorado River below. Draw five Kayak Kids shooting the rapids in this practice space. Follow the lesson on page 132 of your lesson book.

Kazoo Kingdom

Create a cool Kazoo Kingdom in the practice space below. Follow the lesson on page 133 of your lesson book.

Kissing Killers

Practice drawing four sets of Kissing Killers in the practice space below.

Knocking Knuckles

Time to practice drawing the human hand some more. Draw fourteen knocking knuckles below. Use sunburst lines to simulate knocking action lines. Follow the lesson on page 135 of your *Drawing in 3-D* lesson book.

Kooky Keyhole

I really want you to go crazy with bonus detail in this drawing. In the space below, draw six separate keyholes, making each one wildly different and unique. Remember the thickness rules. Follow the lesson on page 136 of your lesson book.

Puff Cloud Letter *L*

Use your pencil to draw seven soft Puff Cloud Letters in the practice space below. Follow the lesson on page 137 of your lesson book.

Peeling Shadow Letter *L*

I want you to draw five unbelievably cool Peeling Shadow Letters. Focus on how the shadow peels away from the letter.

Chiseled-Stone Letter *L*

Chisel out eight very sharp-looking Chiseled-Stone Letters.

Super 3-D Letter *L*

Before drawing your Super 3-D Letters, I want you to warm up by practicing five foreshortened squares in the space below. Then illustrate six Super 3-D Letters.

Block 3-D Letter *L*

Before working on the Block 3-D Letters, draw eight more foreshortened squares in the practice space below. Now draw five Block 3-D Letters below.

Large Labyrinth

In the space below, draw a 3-D labyrinth so large that it takes your friends over an hour to figure out how to get through it! This is your amazing maze of imagination! Follow the lesson on pages 138 and 139 of your lesson book.

Launch Lever

Prepare for imagination launch. Get your pencil prepared for creativity-booster rocket-thrusters one and two. Buckle up your safety art attack harness. Release hesitation restraints one through sixteen. Countdown: five, four, three, two, we have ignition and liftoff. Soar across the galaxy of 3-D drawing in the space below. Draw a long overlapping mountain range with a launch lever on top. Follow the lesson on page 140 of your lesson book.

Leering Lasagna

Noodles, noodles, everywhere! In the practice space below, sketch an entire colony of Leering Lasagna noodles invading your kitchen table. Follow the lesson on page 141 of your lesson book.

Long Links

Build your powerful 3-D drawing skill one link at a time. Draw thirty–one locking links in the practice space below. Follow the lesson on page 142 of your lesson book.

Lunging Lizard

Lunge your pencil aggressively across the practice space below with the confidence of a true paper dominator! Draw three Lunging Lizards using natural design and spots below. Follow the lesson on page 143 of your lesson book.

Puff Cloud Letter *M*

Use your pencil to draw seven soft Puff Cloud Letters in the practice space below. Follow the lesson on page 144 of your lesson book.

Peeling Shadow Letter *M*

I want you to draw five unbelievably cool Peeling Shadow Letters. Focus on how the shadow peels away from the letter.

Chiseled-Stone Letter *M*

Chisel out eight very sharp-looking Chiseled-Stone Letters.

Super 3-D Letter *M*

Before drawing your Super 3-D Letters, I want you to warm up by practicing five foreshortened squares in the space below. Then illustrate six Super 3-D Letters.

Block 3-D Letter *M*

Before working on the Block 3-D Letters, draw eight more foreshortened squares in the practice space below. Now draw five Block 3-D Letters below.

Magnificent Macaroni

Use blocking to sketch one hundred chatting macaronis in the practice space below. Follow the lesson on page 146 of your lesson book.

Maniac Mouse

Practice adding shadows to eighteen Maniac Mice on pencil power rockets in the practice space below. Follow the lesson on page 147 of your lesson book.

Meandering Manatee

Meander with the many marvelous mischievous manatees in the practice space below. Follow the lesson on page 148 of your lesson book.

Migrating Martian

Migrate across the practice space below with a funny family of aliens.
Follow the lesson on page 149 of your lesson book.

Moon Mobile

Draw a superlong Moon Mobile with twenty–seven compartments in the
practice space below. Follow the lesson on pages 150 and 151 of your
lesson book.

Puff Cloud Letter *N*

Use your pencil to draw seven soft Puff Cloud Letters in the practice space below. Follow the lesson on page 152 of your lesson book.

Peeling Shadow Letter *N*

I want you to draw five unbelievably cool Peeling Shadow Letters. Focus on how the shadow peels away from the letter.

Chiseled-Stone Letter *N*

Chisel out eight very sharp-looking Chiseled-Stone Letters.

Super 3-D Letter *N*

Before drawing your Super 3-D Letters, I want you to warm up by practicing five foreshortened squares in the space below. Then illustrate six Super 3-D Letters.

Block 3-D Letter *N*

Before working on the Block 3-D Letters, draw eight more foreshortened squares in the practice space below. Now draw five Block 3-D Letters below.

Near NASA

It's pencil power launch time. Blast off with five imagination shuttle rockets in the practice space below. Follow the lesson on page 153 of your lesson book.

Neptune Ned

How many spiffy little 3-D aliens can you draw in 3-D below? Follow the lesson on page 154 of your *Drawing in 3-D* lesson book.

Nice Neanderthal

Let's travel back in time a few centuries. In the practice space below, sketch a family of Nice Neanderthals playing a game of pick-up sticks together. Follow the lesson on page 155 of your lesson book.

Nine Nostrils

Show me just how wild your imagination is! In the practice space below, sketch a 3-D nose so large that it has nineteen nostrils! Remember the thickness rule: If the nostril is on the right side, the thickness is on the right. And if the nostril is on the left, the thickness is on the left. Follow the lesson on page 156 of your lesson book.

Noisy Nest

I'm sure this is how your breakfast table sounds each morning when your brothers and sisters gather around it! Draw your family in the comfy nest below. Follow the lesson on pages 157 and 158 of your lesson book.

Puff Cloud Letter *O*

Use your pencil to draw seven soft Puff Cloud Letters in the practice space below. Follow the lesson on page 159 of your lesson book.

Peeling Shadow Letter *O*

I want you to draw five unbelievably cool Peeling Shadow Letters. Focus on how the shadow peels away from the letter.

Chiseled-Stone Letter *O*

Chisel out eight very sharp-looking Chiseled-Stone Letters.

Super 3-D Letter *O*

Before drawing your Super 3-D Letters, I want you to warm up by practicing five foreshortened squares in the space below. Then illustrate six Super 3-D Letters.

Block 3-D Letter *O*

Before working on the Block 3-D Letters, draw eight more foreshortened squares in the practice space below. Now draw five Block 3-D Letters below.

Okey Dokey

Show the world it's okay to be a creative 3-D drawing genius! Illustrate eight pairs of hands below. Follow the lesson on page 160 of your lesson book.

Oooops!

Let your genius imagination spill across the practice space below. Follow the lesson on page 161 of your *Drawing in 3-D* lesson book.

Oriental Othello

This is a fantastic drawing to practice Plaid and Checkers augmenting art patterns. Follow the lesson on page 162 of your lesson book.

Ouch!

Draw a Dino dude below using lots of shading, shadows, and overlapping. Follow the lesson on page 163 of your lesson book.

Overflowing Operation

This is what I look like attempting to do my weekly laundry. Draw a chaotic bubble scene below. Follow the lesson on page 164 of your lesson book.

Puff Cloud Letter *P*

Use your pencil to draw seven soft Puff Cloud Letters in the practice space below. Follow the lesson on page 165 of your lesson book.

Peeling Shadow Letter *P*

I want you to draw five unbelievably cool Peeling Shadow Letters. Focus on how the shadow peels away from the letter.

Chiseled-Stone Letter *P*

Chisel out eight very sharp-looking Chiseled-Stone Letters.

Super 3-D Letter *P*

Before drawing your Super 3-D Letters, I want you to warm up by practicing five foreshortened squares in the space below. Then illustrate six Super 3-D Letters.

Block 3-D Letter *P*

Before working on the Block 3-D Letters, draw eight more foreshortened squares in the practice space below. Now draw five Block 3-D Letters below.

Peaceful Pelican

Use the augmenting art accent S curve to sketch fourteen Peaceful Pelicans in the practice space below. Follow the lesson on page 166 of your lesson book.

Pencil Power

Smash out of the paper in 3-D with a cool picture of Pencil Power below. This is a great drawing to sketch on the outside of envelopes before you mail your letters to friends! Follow the lesson on page 167 of your lesson book.

Pirouetting Pandas

Draw three playful Pirouetting Pandas in the practice space below. Use action lines to make them dance across the paper. Follow the lesson on pages 168 and 169 of your *Drawing in 3-D* lesson book.

Positive Poetry

Draw the 3-D foot in the space below. Now write your own Positive Poetry in a balloon above the mouse. Make copies of your Positive Poetry for your classmates. Now you are a published author-illustrator! Follow the lesson on page 170 of your lesson book.

Pudding Plant

Quick! The colony on Planet Mars needs a new Pudding Plant to keep up with the demand. In the space below draw six two-point perspective buildings attached with pudding hoses. Follow the lesson on pages 171 and 172 of your lesson book.

Puff Cloud Letter *Q*

Use your pencil to draw seven soft Puff Cloud Letters in the practice space below. Follow the lesson on page 173 of your lesson book.

Peeling Shadow Letter *Q*

I want you to draw five unbelievably cool Peeling Shadow Letters. Focus on how the shadow peels away from the letter.

Chiseled-Stone Letter *Q*

Chisel out eight very sharp-looking Chiseled-Stone Letters.

Super 3-D Letter *Q*

Before drawing your Super 3-D Letters, I want you to warm up by practicing five foreshortened squares in the space below. Then illustrate six Super 3-D Letters.

Block 3-D Letter *Q*

Before working on the Block 3-D Letters, draw eight more foreshortened squares in the practice space below. Now draw five Block 3-D Letters below.

Quack! Quack!

Notice how the duck's bill uses a foreshortened square shape? Draw a flock of fourteen quacking ducks in the practice space below. Follow the lesson on page 174 of your *Drawing in 3-D* lesson book.

Queasy Quagmire

If your friends thought your drawing of the Large Labyrinth was difficult to navigate through, wait until they attempt your 3-D sketch of the Queasy Quagmire! Follow the lesson on page 175 of your lesson book.

Queen Bean

Be the king or queen of the land of imagination! Draw a row of eleven royal beans in 3-D thrones in the space below. Follow the lesson on page 176 of your lesson book.

Question Queue

Answer all of your friends' questions about how you can draw such excellent 3-D renderings with this drawing. In the practice space below, draw twenty-seven question marks lined up in 3-D. Follow the lesson on page 177 of your lesson book.

Quilt Quest

You are on a great noble quest to find the land of Drawing. Gather your fellow explorers and prepare to depart on this journey into 3-D thinking. Follow the lesson on page 178 of your lesson book.

Quirky Choir

Let your dynamic pencil sing out loud your wonderful genius personality!
Draw a choir group of thirty-four overlapping singing characters below.
Follow the lesson on pages 179 and 180 of your lesson book.

Puff Cloud Letter *R*

Use your pencil to draw seven soft Puff Cloud Letters in the practice space
below. Follow the lesson on page 181 of your lesson book.

Peeling Shadow Letter *R*

I want you to draw five unbelievably cool Peeling Shadow Letters. Focus on how the shadow peels away from the letter.

Chiseled-Stone Letter *R*

Chisel out eight very sharp-looking Chiseled-Stone Letters.

Super 3-D Letter *R*

Before drawing your Super 3-D Letters, I want you to warm up by practicing five foreshortened squares in the space below. Then illustrate six Super 3-D Letters.

Block 3-D Letter *R*

Before working on the Block 3-D Letters, draw eight more foreshortened squares in the practice space below. Now draw five Block 3-D Letters below.

Radical Road

Really roll your pencil across the paper in this drawing. Fill the space below with a supernifty rollercoaster of 3-D roadways. Follow the lesson on page 183 of your *Drawing in 3-D* lesson book.

Romantic Rose

You can get ideas for your 3-D sketches from nature and the world around you. Nature is the best teacher of the augmenting art accents. Draw a dozen roses in a foreshortened vase below. Follow the lesson on page 184 of your lesson book.

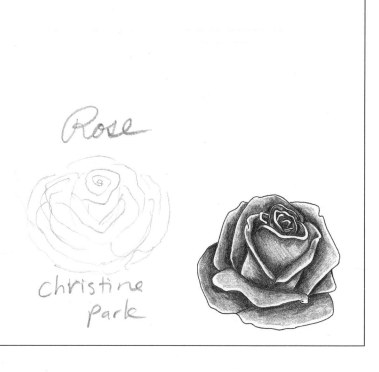

Royal Ribbons

Grouping and balance are the two augmenting art accents that really make this sketch fun to look at. Not to mention the wonderful variety and bonus ideas that you can pack into the practice space below. Follow the lesson on pages 184 and 185 of your lesson book.

Rubbish Reconnaissance

Stack up a thirty-foot high pile of recyclable rubbish in the space below.
Draw yourself leading an expedition to the top of this 3-D mountain of
intricate nooks and crannies. Follow the lesson on page 186 of your lesson
book.

Ruminating Rhino

This is probably my favorite drawing lesson in the whole book. I enjoyed
drawing this one so much I made T-shirts out of the Rhino for my three
hundred summer school kids. Draw eight Ruminating Rhinos below.
Follow the lesson on page 187 of your lesson book.

Puff Cloud Letter *S*

Use your pencil to draw seven soft Puff Cloud Letters in the practice space below. Follow the lesson on page 188 of your lesson book.

Alliteration alert! Satisfying savory Ss slowly simmered salty sardines!

Peeling Shadow Letter *S*

I want you to draw five unbelievably cool Peeling Shadow Letters. Focus on how the shadow peels away from the letter.

Chiseled-Stone Letter *S*

Chisel out eight very sharp-looking Chiseled-Stone Letters.

Super 3-D Letter *S*

Before drawing your Super 3-D Letters, I want you to warm up by practicing five foreshortened squares in the space below. Then illustrate six Super 3-D Letters.

Block 3-D Letter *S*

Before working on the Block 3-D Letters, draw eight more foreshortened squares in the practice space below. Now draw five Block 3-D Letters below.

Sailing Sloop

Pretend the practice space below is an ocean of creative ideas. Draw a regatta of superdetailed 3-D Sailing Sloops riding the swells of creativity below. Follow the lesson on page 190 of your lesson book.

Scary Snarl

Grrrrrrrrrrrrrrrrrrrr! This is what I look like when I lose my drawing pencils. Grrrrrrrrr! Draw a pack of snarling dogs in the practice space below. Follow the lesson on page 191 of your lesson book.

Shoe Sleuth

Do you ever wonder what happens to your shoes in the morning when you can't find them and you're running late for the school bus? It's the Shoe Sleuth I tell you! Follow the lesson on pages 191 and 192 of your lesson book.

Spectacular Spider

Spiders are so cool to draw. They have so many interesting features you can exaggerate for a great cartoon illustration. Sketch a dozen Spectacular Spiders below. Follow the lesson on page 192 of your lesson book.

Surfing Steve

I wonder why this is my brother Stephen's favorite lesson? Draw an enormous 3-D wave of success crashing across your sketchpad below. Follow the lesson on page 193 of your lesson book.

Puff Cloud Letter *T*

Use your pencil to draw seven soft Puff Cloud Letters in the practice space below. Follow the lesson on page 194 of your lesson book.

Peeling Shadow Letter *T*

I want you to draw five unbelievably cool Peeling Shadow Letters. Focus on how the shadow peels away from the letter.

Chiseled-Stone Letter *T*

Chisel out eight very sharp-looking Chiseled-Stone Letters.

Super 3-D Letter *T*

Before drawing your Super 3-D Letters, I want you to warm up by practicing five foreshortened squares in the space below. Then illustrate six Super 3-D Letters.

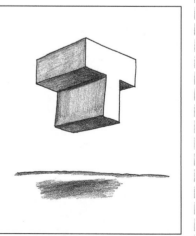

Block 3-D Letter *T*

Before working on the Block 3-D Letters, draw eight more foreshortened squares in the practice space below. Now draw five Block 3-D Letters below.

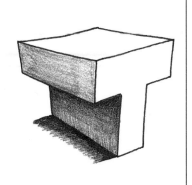

Thick Thumb

Thumbs up for pencil power! Follow the lesson on page 196 of your lesson book.

Throg's Throne

Long Live Throg! Draw fourteen thrones for Throg below. Follow the lesson on page 197 of your lesson book.

Tongue Twister

Twist a totally tangled 3-D tongue below. Follow the lesson on page 198 of your *Drawing in 3-D* lesson book.

Tremendous Toad

Hop across the page below with nine Tremendous Toads. Follow the lesson on page 198 of your lesson book.

Tube Tag

Tag, you're it! Use foreshortening and size to play Tube Tag in the practice space below. Follow the lesson on page 199 of your lesson book.

Puff Cloud Letter *U*

Use your pencil to draw seven soft Puff Cloud Letters in the practice space below. Follow the lesson on page 200 of your lesson book.

Peeling Shadow Letter *U*

I want you to draw five unbelievably cool Peeling Shadow Letters. Focus on how the shadow peels away from the letter.

Chiseled-Stone Letter *U*

Chisel out eight very sharp-looking Chiseled-Stone Letters.

Super 3-D Letter *U*

Before drawing your Super 3-D Letters, I want you to warm up by practicing five foreshortened squares in the space below. Then illustrate six Super 3-D Letters.

Block 3-D Letter *U*

Before working on the Block 3-D Letters, draw eight more foreshortened squares in the practice space below. Now draw five Block 3-D Letters below.

Uncle Ugly

Draw a variety of very peculiar-looking trolls in the space below. Follow the lesson on page 202 of your lesson book.

Unicycling Unibear

Use the augmenting art accents twist, balance, and texture on the balancing Unibear below. Follow the lesson on pages 202 and 203 of your lesson book.

Upset Urnie

Urnie has lost his Drawing in 3-D sketchpad. Draw his lost expression below. Follow the lesson on page 203 of your lesson book.

Uranus University

Wow! Lots of extra bonus detail ideas in this creature. Draw a 3-D Uranus University graduate below with twelve overlapping eyes. Follow the lesson on page 204 of your lesson book.

Urban Utopia

Excuse me, which way is it to Drawville? Sketch a 3-D direction post with ten arrows nailed in different directions. Follow the lesson on page 205 of your *Drawing in 3-D* lesson book.

Puff Cloud Letter *V*

Use your pencil to draw seven soft Puff Cloud Letters in the practice space below. Follow the lesson on page 206 of your lesson book.

Peeling Shadow Letter *V*

I want you to draw five unbelievably cool Peeling Shadow Letters. Focus on how the shadow peels away from the letter.

Chiseled-Stone Letter *V*

Chisel out eight very sharp-looking Chiseled-Stone Letters.

Super 3-D Letter *V*

Before drawing your Super 3-D Letters, I want you to warm up by practicing five foreshortened squares in the space below. Then illustrate six Super 3-D Letters.

Block 3-D Letter *V*

Before working on the Block 3-D Letters, draw eight more foreshortened squares in the practice space below. Now draw five Block 3-D Letters below.

Vacuuming Vortex

Draw an enormous black hole in the space below. Follow the lesson on page 208 of your lesson book.

Vegetable Virtuoso

Sketch eighteen singing wild carrots below. Use contour lines around the carrots to create depth and volume. Follow the lesson on page 209 of your lesson book.

Vertical Vine

Pretend you are searching for Jack in the great beanstalk. Draw a knarly, twisting, tall, thorny overlapping vine in the practice space below. Follow the lesson on page 210 of your lesson book.

Viking Voyage

Take an incredible voyage across the Atlantic ocean with the Vikings of times past. Follow the lesson on pages 211 and 212 of your lesson book.

Vrooom!

Vrooom your pencil power through six 3-D overlapping clouds. These clouds are similar to your puffy cloud-textured letters. Follow the lesson on page 213 of your lesson book.

Puff Cloud Letter *W*

Use your pencil to draw seven soft Puff Cloud Letters in the practice space below. Follow the lesson on page 214 of your lesson book.

Peeling Shadow Letter *W*

I want you to draw five unbelievably cool Peeling Shadow Letters. Focus on how the shadow peels away from the letter.

Chiseled-Stone Letter *W*

Chisel out eight very sharp-looking Chiseled-Stone Letters.

Super 3-D Letter *W*

Before drawing your Super 3-D Letters, I want you to warm up by practicing five foreshortened squares in the space below. Then illustrate six Super 3-D Letters.

Block 3-D Letter *W*

Before working on the Block 3-D Letters, draw eight more foreshortened squares in the practice space below. Now draw five Block 3-D Letters below.

Walter's Wig

Draw Walter's wacky, waving wig below. Follow the lesson on page 216 of your lesson book.

Alliteration Alert! Walter's wavy wig wilts with wind.

Your turn!_____.

Web Wizard

Wow, Web Wizard walks weird! Draw six Web Wizards below. Now log on the Internet and meet Web Wizard in cyberspace at www.draw3d.com. Follow the lesson on page 217 of your lesson book.

Wild Wave

This drawing looks like your creative potential for awesome success in your life! Draw an outrageously cool crashing wave below. Follow the lesson on page 218 of your lesson book.

Wonderful Whale

Dive deep into the ocean with these five graceful whales you have drawn in 3-D below. Follow the lesson on page 219 of your lesson book.

Woooo!

Sketch more dino dudes below! Follow the lesson on page 220 of your lesson book.

Puff Cloud Letter *X*

Use your pencil to draw seven soft Puff Cloud Letters in the practice space below. Follow the lesson on page 221 of your lesson book.

Peeling Shadow Letter *X*

I want you to draw five unbelievably cool Peeling Shadow Letters. Focus on how the shadow peels away from the letter.

Chiseled-Stone Letter *X*

Chisel out eight very sharp-looking Chiseled-Stone Letters.

Super 3-D Letter *X*

Before drawing your Super 3-D Letters, I want you to warm up by practicing five foreshortened squares in the space below. Then illustrate six Super 3-D Letters.

Block 3-D Letter *X*

Before working on the Block 3-D Letters, draw eight more foreshortened squares in the practice space below. Now draw five Block 3-D Letters below.

Xeroxing Xylophone
Xerox your masterpiece drawings and give them to all your friends!

X-ing
Follow the lesson on page 224 of your lesson book. This is a sign that your drawings are brilliant!

eXpensive Xmas

Follow the lesson on pages 224 and 225 of your drawing book. Give your drawings this year as holiday gifts! They are not eXpensive, they are eXtraordinary!

eXploding eXpression

Follow the lesson on pages 225 and 226 of your lesson book. Let your creativity eXplode across the space below!

X-ray eXpert

Follow the lesson on page 226 of your lesson book. Draw an entire planet of X-ray eXperts in the space below.

Alliteration Alert! X-ray eXpert examines extraterrestrial's exquisite exoskeleton.

Your turn! _____

_____.

Puff Cloud Letter *Y*

Use your pencil to draw seven soft Puff Cloud Letters in the practice space below. Follow the lesson on page 227 of your lesson book.

Peeling Shadow Letter *Y*

I want you to draw five unbelievably cool Peeling Shadow Letters. Focus on how the shadow peels away from the letter.

Chiseled-Stone Letter *Y*

Chisel out eight very sharp-looking Chiseled-Stone Letters.

Super 3-D Letter *Y*

Before drawing your Super 3-D Letters, I want you to warm up by practicing five foreshortened squares in the space below. Then illustrate six Super 3-D Letters.

Block 3-D Letter *Y*

Before working on the Block 3-D Letters, draw eight more foreshortened squares in the practice space below. Now draw five Block 3-D Letters below.

Yeehaw!

Follow the lesson on page 229 of your lesson book. Hold on! Your imagination pencil power is about to race across the space below!

Yelling Yahtzee!

Follow the lesson on page 230 of your lesson book. Draw 32 dice in different positions below. Use lots of foreshortening, size, and overlapping.

Yellow Yolk

Follow the lesson on page 231 of your lesson book. This is your brain when you don't draw daily. Any questions?

Yodeling Yop

Follow the lesson on page 231 of your lesson book. Go outside and yodel loudly for three minutes. Now you are ready to truly be a pencil power paper dominator!

Yummmm

Follow the lesson on page 232 of your lesson book. Go grab some cheese and a glass of milk. This drawing is going to make you hungry for more!

Puff Cloud Letter *Z*

Use your pencil to draw seven soft Puff Cloud Letters in the practice space below. Follow the lesson on page 233 of your lesson book.

Peeling Shadow Letter *Z*

I want you to draw five unbelievably cool Peeling Shadow Letters. Focus on how the shadow peels away from the letter.

Chiseled-Stone Letter *Z*

Chisel out eight very sharp-looking Chiseled-Stone Letters.

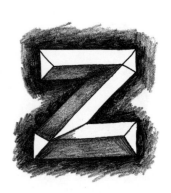

Super 3-D Letter *Z*

Before drawing your Super 3-D Letters, I want you to warm up by practicing five foreshortened squares in the space below. Then illustrate six Super 3-D Letters.

Block 3-D Letter *Z*

Before working on the Block 3-D Letters, draw eight more foreshortened squares in the practice space below. Now draw five Block 3-D Letters below.

Zachary Zot

Exercise your pencil power with Zachary Zot. Draw fifteen Zots lifting fore-shortened blocks in two-point perspective below. This is a really great drawing to teach a friend the basics of two-point perspective (vanishing-point alignment). Remember, it simplifies things a lot if you use a clear-plastic ruler to keep your edges lined up with your vanishing guide dots. Or you can use the rubber band between two thumbtacks stuck into your guide dots. The rubber band does a terrific job of keeping the edges lined up. Move the rubber band around to double check all of your alignment. Follow the lesson on page 235 of your lesson book.

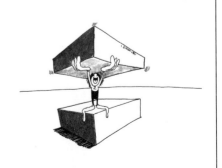

Zapping Zombies

Follow the lesson on page 236 of your lesson book. Zap your imagination across the page. Draw in 3-D!

Zesty Zephyr

Follow the lesson on page 237 of your lesson book. Let your creative genius blow your paper off the desk!

Zippered Zeros

Follow the lesson on page 238 of your lesson book. Draw ten zippered zeros zigzagging down a long lane below.

"ZIPITYZZZZZ"

Alliteration Alert! Zany zippered zeros zigzagged zealously.

Your turn! _____

_____.

ZZZZZZZZ

Follow the lesson on page 239 of your lesson book. Congratulations! You've drawn over 333 imagination adventures with me in 3-D! It's hard to say goodbye after so much great drawing fun. I look forward to blasting across the paper with you again in my next book, on TV, or perhaps on the Internet at www.draw3d.com! Now draw an eight-mile-long tube with my brother Karl taking a nap. ZZZZZZ